HEART, HEAD AND HANDS

AN INTRODUCTION

My name is Sarah. I have always been an activist, but four years ago I was a burnt out activist and was actually thinking whether I would have to give up fighting for a better world.

I have always been passionate about challenging injustices. Growing up in a low-income area of Liverpool in the 1980s, my parents raised me in the world of activism. There are photos of me aged five holding a beaker of juice alongside protesters trying to save good local housing from demolition. At school I was voted Head Girl, and successfully campaigned for lockers so that pupils would not have to carry heavy bags from lesson to lesson. At university I was active in numerous campaign groups, and as an adult I've been fortunate enough to work for various international charities in their youth and community programmes and campaigns departments.

However, in 2008, I found myself feeling discouraged and exhausted. Shouting and marching drained me; I didn't like demonising people and telling them what to do. I didn't feel that I fitted into some activist groups. Around the same time I started to cross-stitch as a hobby which I loved. It gave me time to refle Then something click ngage myself and othe g and deeply engaging r and became a craftiv

Betsy Greer c rough craft) in 2003 and defined it as "a way of looking at life where voicing opinions through creativity makes your voice stronger, your compassion deeper." There were no craftivism groups or

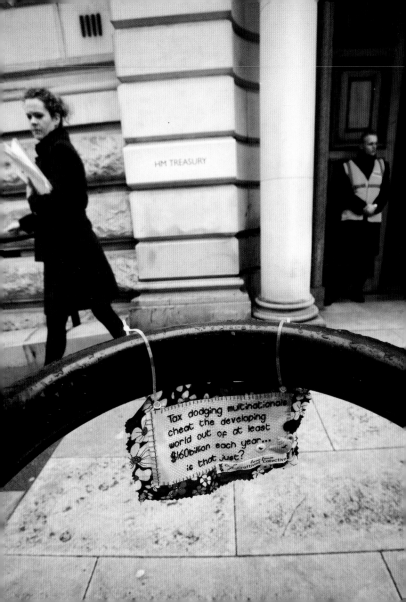

HM TREASURY

Tax dodging multinationals cheat the developing world out of at least $160billion each year... is that just?

craftivist collective

projects I could join, and so, with Betsy's blessing, I started creating my own projects and documenting them under my blog, 'A Lonely Craftivist'.

The first thing that I experienced is that craftivism is 'slow activism'. It gave me an opportunity to reflect in a way that I hadn't really made time for before. Much activism is fast: sign this petition, click here, march there. Craft is naturally slow. Therefore, it forces you to make time to stop and reflect on what the issues mean, whom injustice affects and how we can be part of a solution. Craft connects your heart, head and hands, and when you relate that to justice issues, it can be world-changing personally and politically.

Secondly, I felt that many traditional forms of activism actually annoyed the very people they were trying to influence. I wasn't convinced that shouting, preaching and demanding someone to do a particular action would change their mind and result in any long-lasting change. When I moved to my current home I continued to sign petitions and the first correspondence I got from my local Member of Parliament was to tell me to stop. She said it was wasting her time and mine. I was shocked. But then I thought that she had a point. I didn't know her, she didn't know me. She didn't know whether I genuinely cared about these issues I was quickly signing petitions about. So I decided to hand-embroider her a message on a handkerchief asking her to use her power and influence to support the most vulnerable in society, and not to blow her chance of making a positive difference in the world. I met her in person and gave her the hanky with a smile. The craftivism gift created a safe space for us to get to know each other, and to find ways of working together as well as challenge each other as critical friends. In fact, the hanky is now a permanent fixture on her constituency office desk, to encourage her in both a political and a personal context. The Craftivist Collective's projects are small, attractive and unthreatening. Our mini protest banners or cross-stitched masks catch the attention of passers-by in a respectful and thought-provoking way without

forcing our views on them. In the words of one of our craftivists, Rosa Martyn, "a spoonful of craft helps the activism go down".

Thirdly, as an activist I always felt that I was asking people to come to activism activities rather than reaching out to people where they are. With craftivism, we encourage people to meet up in small numbers to create craftivist projects in public places or on their own on public transport. As we stitch, people come and ask us what we are doing, initiating the conversation themselves rather than us forcing a dialogue onto them. They engage in a conversation or a discussion about the issue we are working around, and because it's an unusual activity to see, they are more likely to go away and discuss it further with their friends or share it through online social media.

I founded the Craftivist Collective in 2009, after other craft-lovers around the world contacted me through my 'A Lonely Craftivist' blog, asking to join in my craftivist projects. The Collective now has thousands of members all over the world working on projects on their own or in groups. We get sympathetic organisations who want to collaborate – from cult jewelers Tatty Devine, who work with us on our annual Valentine's Day project, to London's Secret Cinema, where we engaged 5,000 cinema-goers dressed up as prisoners in a group craft project on the issue of the prison system's revolving door problem. Our approach reaches out beyond the normal bounds of activism, providing a provocative, non-violent, creative platform from which to open up conversations about global injustices. In the words of our manifesto, we aim to "expose the scandal of global poverty and human rights injustices through the power of craft and public art".

I'm happy to say that I no longer feel burnt out and am now a thriving craftivist, literally threading activism through everything I do. I believe that the benefits of craftivism make it a valid form of activism both personally and politically that can be a permanent part of the activism tool kit. I hope you do too.

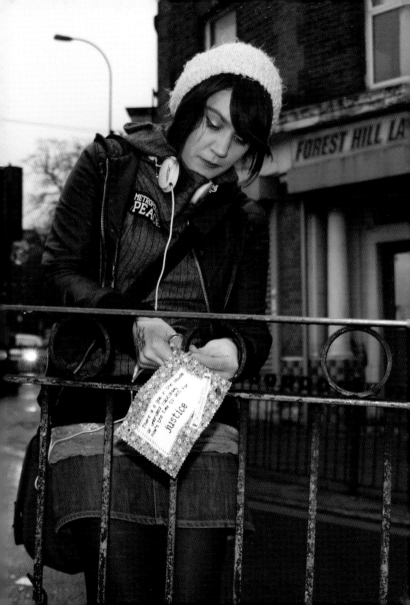

HOW TO CROSS-STITCH

CROSS-STITCHING IS A UNIQUELY MEDITATIVE CRAFT – I FIND THAT THE REPETITION REALLY HELPS MY MIND FOCUS, TAKING ME AWAY FROM THE NOISE AND ANXIETY OF THE WORLD, ALLOWING ME TO CONCENTRATE ON THE MESSAGE I'M TRYING TO CONVEY WITHOUT GETTING TOO DEPRESSED OR DISEMPOWERED BY THE INJUSTICES I AM ADDRESSING. WHAT'S EVEN BETTER IS THAT IT'S COMPACT AND LIGHT, SO YOU CAN DO IT ANYWHERE – AND MAYBE OPEN UP DISCUSSIONS ABOUT YOUR PROJECT WITH INTRIGUED ONLOOKERS.

Fig A

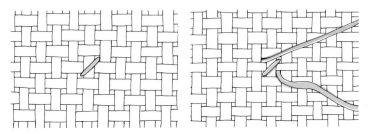

Materials

- Aida fabric (I recommend size 14 for a craftivism project that's big enough to read but not overpowering)
- Small tapestry needle (size 24 if you're working with a 14 count aida)
- Embroidery floss such as Anchor or DMC in your choice of colours

What to do

- Cut a piece of embroidery floss as long as your arm, and then split it in two, so you're working with three strands.
- Plan your slogan on a separate piece of graph paper, or trace it faintly in pencil on your fabric.
- Choose the square you're going to start with, and push your needle up through the bottom left hand corner of the square. Then bring it down through the top right hand corner (fig A).
- Now repeat this to form the second leg of the cross – from the under side, insert the needle into the top left hand corner and complete it by entering the bottom right hand corner from the top side. You can either complete each stitch as you go, or, as I prefer, complete a row of bottom legs and then go back and finish them with a row of top legs (fig B).
- If you're stitching lots of text, you can work in half stitches to speed things up. They can work horizontally or vertically.
- When you come to the end of your thread, or need to switch colours, complete the cross you're stitching and weave the end of the thread in and out of the back of your stitches a few times. Snip the end of the thread carefully.

Fig B

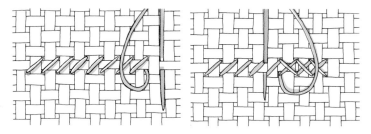

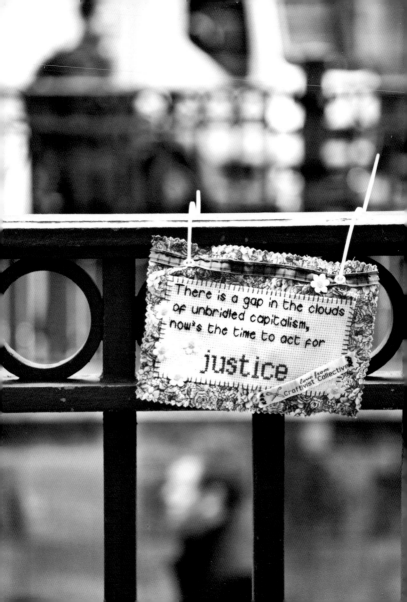

MINI PROTEST BANNERS

THESE ARE OUR MOST SUCCESSFUL PROJECTS TO DATE. THE CONCEPT IS TO MAKE A CROSS-STITCHED BANNER ABOUT AN ISSUE YOU CARE ABOUT AND HANG IT IN A RELEVANT PUBLIC SPACE TO PROVOKE THOUGHT AND DISCUSSION. BY MAKING IT SMALL AND HANGING IT ABOVE OR BELOW EYE LEVEL, PEOPLE HAVE A SENSE THAT THEY HAVE CHOSEN TO ENGAGE WITH THE MESSAGE, RATHER THAN IT BEING FORCED UPON THEM.

Materials

- 14 count aida
- Cute patterned cotton fabric scrap
- Embroidery needle (size 6)
- Blunt tapestry needle
- Embroidery floss
- Embellishments (buttons sequins, ribbon, etc)
- 2 cable ties
- Craftivist Collective label (available online)
- 5mm eyelets (optional)

What to do

- Cut a stretch of thread the length of your arm, and then split it in half, so that you're working with three strands.
- Following the instructions for cross-stitch on pp. 8-9 and for backstitch on p. 23, stitch your message.
- Follow the grid on your aida and cut straight lines around your message, leaving a minimum of 1cm around all the edges.
- Cut your pretty fabric so it's 3cm larger on all sides than the aida fabric.
- Sew the aida fabric onto the pretty fabric.
- Sew the Craftivist Collective label onto the bottom corner, so that people can Google us and find out more.
- If you want to, you can insert eyelets into the top two corners.
- Insert the cable ties and hang on railings or fences in a public location that best fits your message.
- Take a photo, write a blog about your banner and send it to us at craftivist.collective@gmail.com!

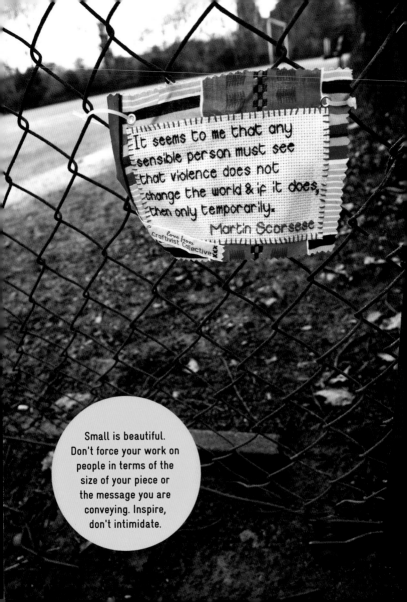

It seems to me that any sensible person must see that violence does not change the world & if it does, then only temporarily.

Martin Scorsese

love from
Craftivist Collective xox

Small is beautiful. Don't force your work on people in terms of the size of your piece or the message you are conveying. Inspire, don't intimidate.

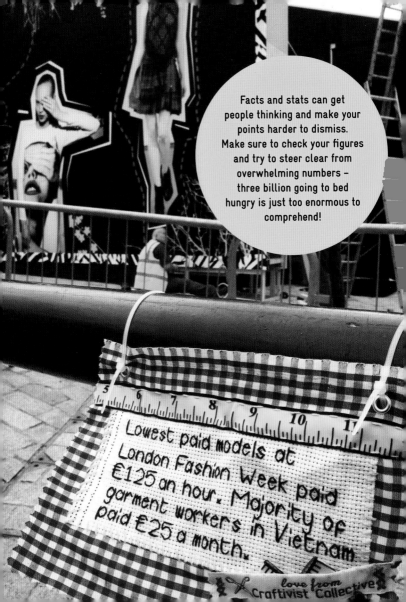

Facts and stats can get people thinking and make your points harder to dismiss. Make sure to check your figures and try to steer clear from overwhelming numbers – three billion going to bed hungry is just too enormous to comprehend!

Lowest paid models at London Fashion Week paid £125 an hour. Majority of garment workers in Vietnam paid £25 a month.

love from Craftivist Collective

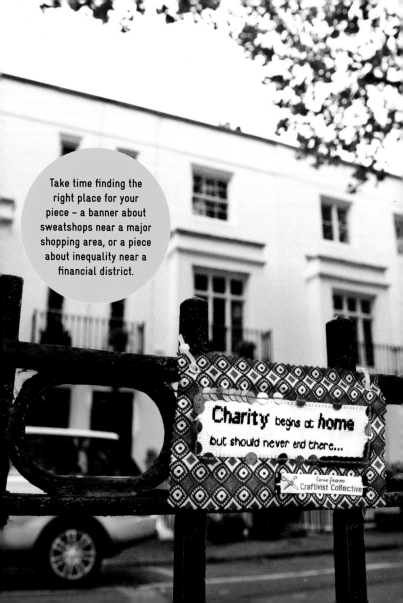

Take time finding the right place for your piece – a banner about sweatshops near a major shopping area, or a piece about inequality near a financial district.

Charity begins at **home** but should never end there...

love from
Craftivist Collective

SOME SLOGAN INSPIRATIONS

When the power of love overpowers the love of power,
the world will know peace. (Jimi Hendrix)

✖✖✖

Rich countries are most responsible for climate change. But
poor countries are hit first and worst by its effects. WTF!?

✖✖✖

They always say time changes things but you actually have
to change them yourself. (Andy Warhol)

✖✖✖

Most cocoa farmers cannot afford to experience the taste of
chocolate... crazy, huh?!

✖✖✖

Earth provides enough to satisfy everyone's needs, but not
everyone's greed.

✖✖✖

Why should I care about future generations? What have they
ever done for me? (Groucho Marx)

✖✖✖

If you are neutral in situations of injustice, you have chosen
the side of the oppressor. (Desmond Tutu)

✖✖✖

Never doubt that a small group of thoughtful, committed
citizens can change the world. Indeed, it is the only thing
that ever has. (Margaret Mead)

✖✖✖

If we have no peace, it is because we have forgotten that we
belong to each other. (Mother Teresa)

✖✖✖

Only when the last tree has died and the last river has been
poisoned and the last fish has been caught will we realise
that we cannot eat money.

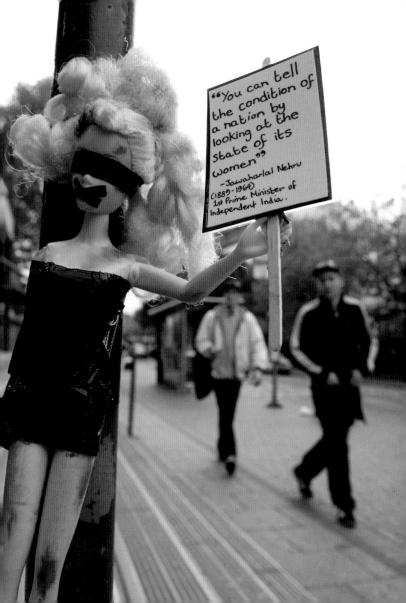

"You can tell the condition of a nation by looking at the state of its women"

-Jawaharlal Nehru
(1889-1964)
1st Prime Minister of
Independent India.

MINI PROTEST MASKS

INSTEAD OF CABLE TIES YOU CAN STITCH TWO LOOPS OF ELASTIC ONTO YOUR
BANNER TO MAKE MASKS. THESE CAN BE VERY STRIKING, RAISING ISSUES OF
OPPRESSION AND CENSORSHIP. IT CAN TAKE A LITTLE WHILE TO FIND A GOOD
SPOT FOR YOUR MASKS. AIM FOR HUMAN-SIZED STATUES TO KEEP A SENSE OF
PROPORTION, BUT STEER CLEAR OF ONES ON HIGH PODIUMS, OR YOUR MASK WILL
BE TOO FAR AWAY TO READ. BEFRIEND A SHOP MANAGER AND ASK IF YOU CAN PUT
A MASK ON ONE OF THE MANNEQUINS IN THEIR SHOP WINDOW.

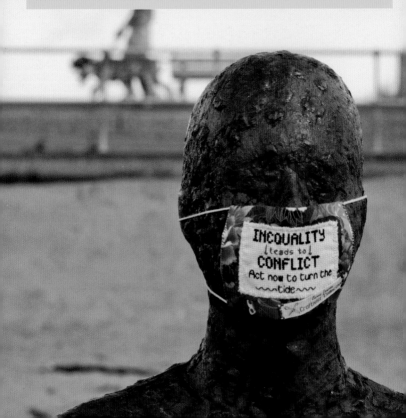

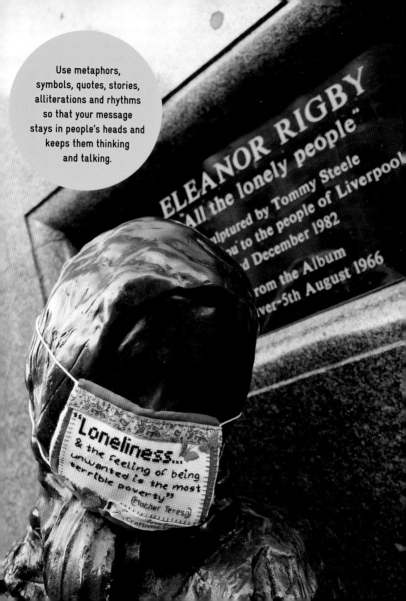

Use metaphors, symbols, quotes, stories, alliterations and rhythms so that your message stays in people's heads and keeps them thinking and talking.

There is no point to a globalisation that reduces the price of a child's shoes, but costs the father his job...

Phrase your thoughts as questions. If you question why injustices are the way they are, you prompt people to think about possible responses.

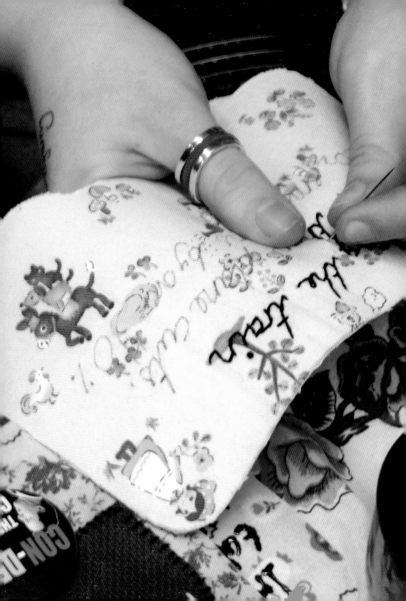

BACKSTITCH

THIS IS A GREAT, VERSATILE STITCH TO LEARN, PERFECT FOR OUTLINES AND TEXT. LIKE CROSS-STITCH, IT'S A REPETITIVE AND THEREFORE MEDITATIVE ACTION, VITAL FOR OUR CRAFTIVISM, BUT UNLIKE CROSS-STITCH, BACKSTITCH CAN CURVE AND FLOW. USED OVER YOUR OWN HANDWRITING, A BACKSTITCHED PIECE CAN MAKE A CRAFTIVIST PROJECT FEEL THAT MUCH MORE PERSONAL AND FROM THE HEART.

Materials

- A plain, even weave fabric or canvas
- Embroidery floss such as Anchor or DMC
- Embroidery needle (I like working with a size 6)

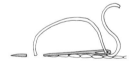

What to do

- Work backstitch from right to left. Bring the needle up through the back (wrong side) of the fabric and make the first stitch by pushing the needle into the fabric behind (to the right of) the thread.
- Bring it back up in front of (to the left of) the thread by the same distance.
- Keep going, bringing the needle back to the previous stitch each time, keeping the length of each stitch as consistent as possible. The shorter the length, the neater the stitches will look, especially when stitching over curly handwriting.

Other stitches to look up in craft books and YouTube:

- French knots are a bit tricky, but very useful to learn for dots on letters and punctuation.
- Blanket stitch is great for edging and borders.
- Research other stitches in books and online, or go crazy and experiment on your own!

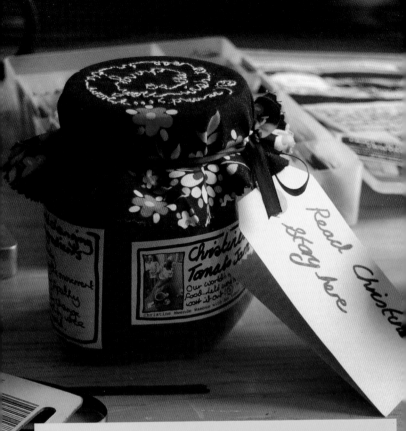

Christine's Tomato Jam

Our wonder...
food...let's
...wait it out ...

Christine Nwende Wambua with ...

Read Christine's story here

JAM JAR PROJECT
--

THIS CAMPAIGN WAS INSPIRED BY A KENYAN WOMAN CALLED CHRISTINE, WHO
WAS MAKING AND SELLING TOMATO JAM IN ORDER TO SUPPORT HER COMMUNITY,
WHICH HAD BEEN TORN APART BY HIV AND CLIMATE CHANGE. WE STITCHED
MESSAGES ONTO TOMATO JAM JAR LIDS, AND SHARED JAM SANDWICHES
WHILE DISCUSSING CHRISTINE'S STORY AND THE INEQUALITY OF THE GLOBAL
FOOD SYSTEM.

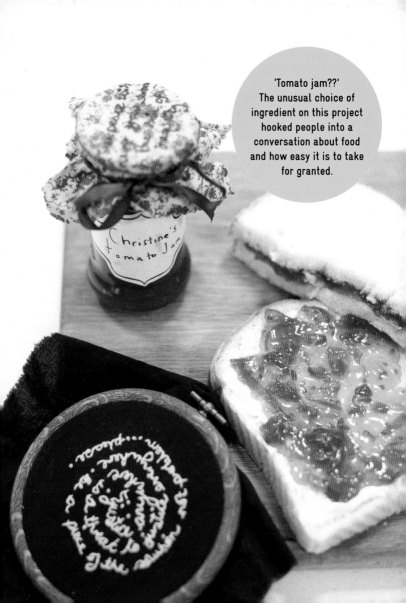

'Tomato jam??'
The unusual choice of ingredient on this project hooked people into a conversation about food and how easy it is to take for granted.

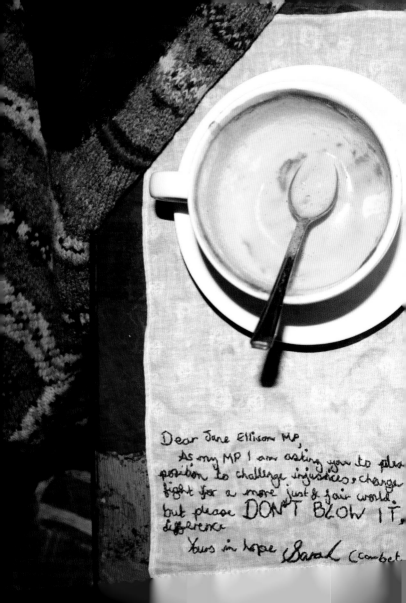

Dear Jane Ellison MP,

As my MP I am asking you to plea...
position to challenge injustices & change
fight for a more just & fair world
but please DON'T BLOW IT,
difference

Yours in hope, Sarah (combet...

Don't blow it!

HANKY PROJECT

IN THE 'DON'T BLOW IT' PROJECT, CRAFTIVISTS EMBROIDER PERSONAL AND
TIMELESS MESSAGES ON HANDKERCHIEFS FOR THEIR MP OR OTHER LOCAL
POLITICIAN, ENCOURAGING THEM TO USE THEIR POWER AND INFLUENCE TO MAKE
A POSITIVE DIFFERENCE. YOU COULD MAKE THE HANKIES FOR OTHER INFLUENTIAL
MEMBERS OF YOUR COMMUNITY; BANKERS, RELIGIOUS LEADERS, JOURNALISTS OR
TEACHERS.

your powerful
s keeping people poor &
eing an MP is a tough big job
your change to make a positive

+e})

FABRIC FOOTPRINTS

THIS PROJECT IS ABOUT ENCOURAGING PEOPLE TO THINK ABOUT THE IMPRINT
THEY ARE LEAVING ON THIS WORLD AND THE JOURNEY THEY ARE ON AS A GLOBAL
CITIZEN. STITCH A THOUGHT, QUOTATION OR LYRIC ONTO A PRINTED FABRIC
FOOTPRINT AND EITHER KEEP IT FOR YOURSELF TO REMIND YOU TO STAY ON THE
RIGHT PATH, OR GIVE IT TO SOMEONE TO ENCOURAGE THEM TO BE THEIR BEST
SELVES AND LEAVE A POSITIVE MARK ON THE PLANET.

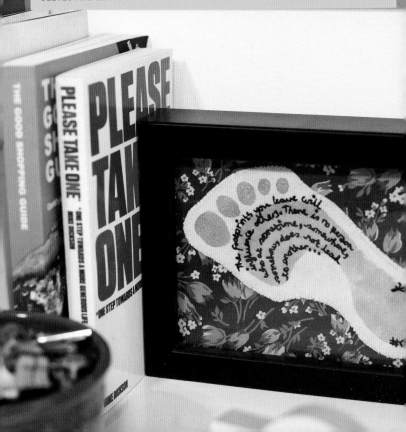

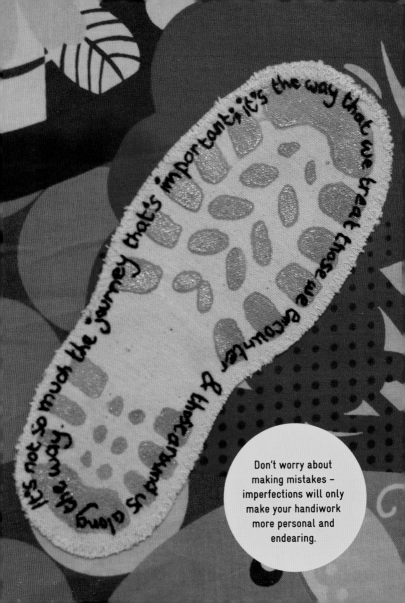

it's the way that we treat those we encounter & the setback's along the route from the source it's not the journey that's important;

Don't worry about making mistakes – imperfections will only make your handiwork more personal and endearing.

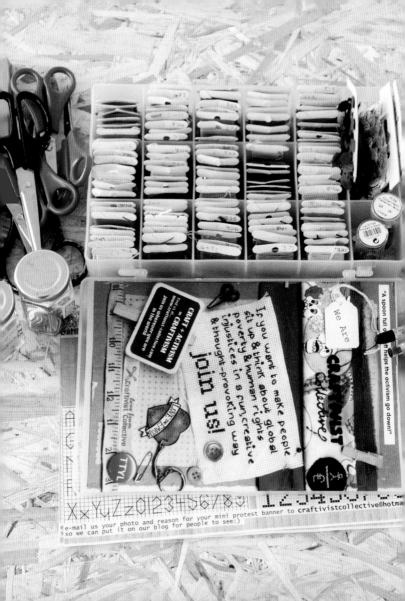

DOS AND DON'TS OF CRAFTIVISM

DON'T rush; let the act of crafting relax you so you can think about why you're doing it as well as what you're doing, how and for whom.

✕✕✕

DON'T initiate a conversation, wait for people to decide to engage with you. This type of craftivism is an introverted activism. It's not about performance and vying for attention, it's about offering people the choice to engage.

✕✕✕

DO keep your message positive and hopeful. It's easy to get angry when you feel passionately about an issue, but positivity is much more inspiring and memorable.

✕✕✕

DON'T demonise, victimise or preach. No one likes to be told what to think or do, or that their lifestyle may be wrong. People need to reach their own conclusions in their own way.

✕✕✕

DO make your message as timeless as possible. Online you can be as specific as you like, but when you're investing time in a physical craft, you want it to have ongoing relevance – that someone might treasure it both physically and philosophically.

✕✕✕

DO show you are in solidarity with the oppressed, and DON'T assume you have all the answers to often complex problems.

POP-UP SUITCASE

WHY NOT BE A POP-UP CRAFTIVIST? AT THE VERY WELCOMING GREENBELT
FESTIVAL, I WANDERED ROUND THE SITE WITH MY LITTLE SUITCASE, HOSTING
IMPROMPTU 'FOOTPRINT WORKSHOPS' AND TALKING ABOUT THE BENEFITS OF
CRAFTIVISM. ALL YOU NEED IS A SUITCASE OF CRAFTIVISM RESOURCES, A LITTLE
SIGN FOR YOUR SUITCASE AND AN APPROACHABLE SMILE.

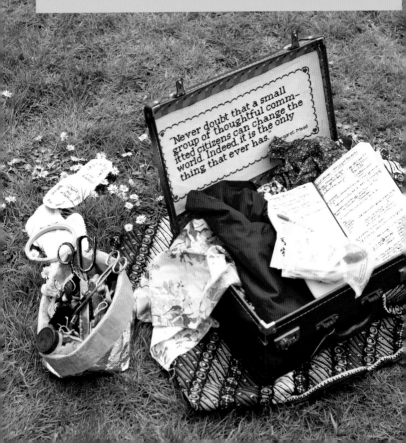

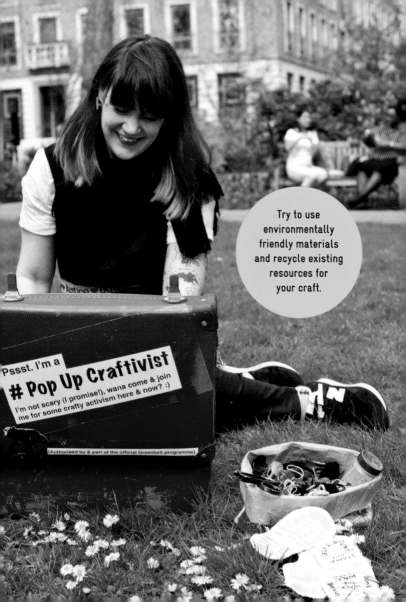

Try to use environmentally friendly materials and recycle existing resources for your craft.

Pssst. I'm a
Pop Up Craftivist
I'm not scary (I promise!), wana come & join me for some crafty activism here & now? :)

[Authorised by & part of the official Greenbelt programme]

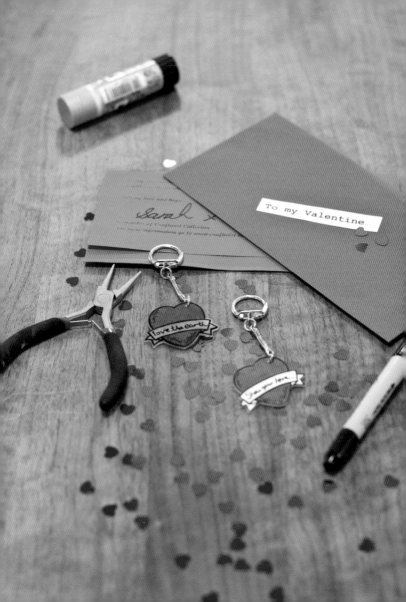

SHRINK PLASTIC VALENTINES

THESE VALENTINE'S DAY CARDS WERE MADE IN COLLABORATION WITH THE CULT JEWELLERS, TATTY DEVINE. EACH ENVELOPE CONTAINS AN ALTERNATIVE, INSPIRING VALENTINE'S DAY LETTER, A HANDMADE KEYRING DESIGNED BY TATTY AND CUSTOMISED BY OUR CRAFTIVISTS AND A SWEET. THEY WERE HAND-DELIVERED TO GAPS IN WALLS, CASH MACHINE SLOTS AND SHOP SHELVES FOR PEOPLE TO FIND.

Materials

- Shrink plastic
- Coloured pencils or marker pens
- Clear nail varnish
- Keyring
- Pliers

What to do

For the keyring

- Copy the design on p. 36 so that it's approximately 11cm wide by 9cm tall.
- Put a piece of shrink plastic over the top and trace the design.
- Using permanent marker or coloured pencil, fill in the heart and write your message in the ribbon. Don't forget to write around the edge 'love from the Craftivist Collective'.
- Cut around the design as close as you can to the edge.
- Using a hole puncher, punch a hole in the top right hand corner where indicated.
- Place on foil on a baking tray in a warm oven until it shrinks to approx 4cm wide by 3cm tall.
- Leave under a heavy book for a few minutes to set flat.
- Thread the keyring through the hole at the top and close using jewellery pliers.
- You can make the keyring design more durable by sealing the colour in with a layer of clear nail varnish. Leave to dry.

For the letter

- Write a personal Valentine's Day letter for someone to find. Encourage them to think about how they might express their love not just for a single person, but for the planet, our fellow human-beings and for future generations.
- If you can, make it handwritten, or if you are making lots, type them out but leave space for a handwritten message at the bottom, saying that the gift is handmade, home-baked and limited edition.
- Sign at the bottom and put the letter and the keyring in a red envelope. You can include a sweet too if you like.
- Go find a good place to put the envelope.

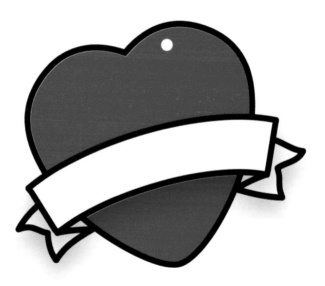

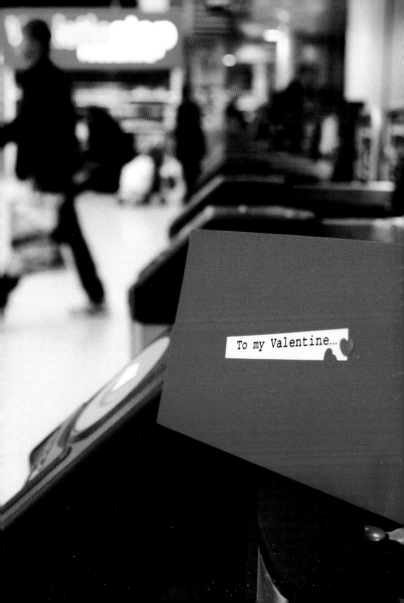

SPEECH BUBBLE BADGES

SHRINK PLASTIC CAN BE GREAT FOR OTHER PROJECTS. STATEMENT BADGES CAN
STIMULATE CONVERSATIONS ABOUT GLOBAL ISSUES. ONE OF OUR CRAFTIVISTS
WROTE ON A BADGE "I'M NOT POOR, I'M BROKE", TO PROVOKE DISCUSSIONS ABOUT
POVERTY AND INEQUALITY AROUND THE WORLD. I WEAR A BADGE THAT SAYS "DO
YOU CARE?", WHICH HAS STARTED SOME REALLY THOUGHTFUL CONVERSATIONS
WITH WAITERS.

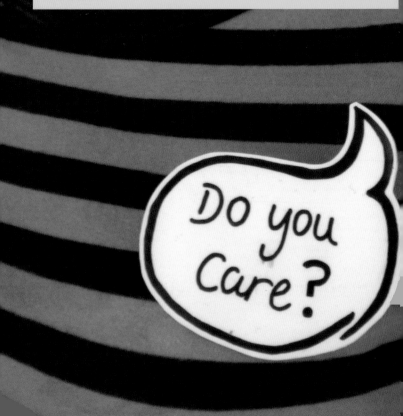

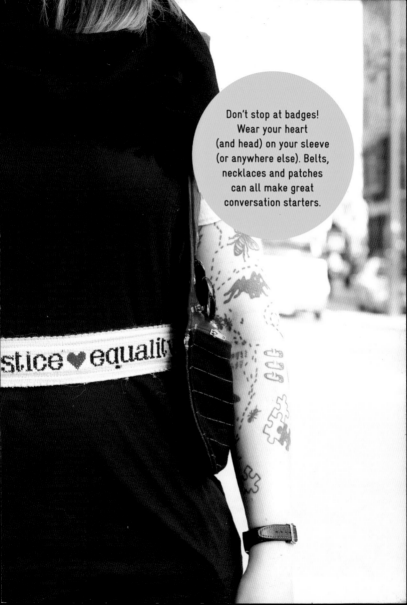

Don't stop at badges! Wear your heart (and head) on your sleeve (or anywhere else). Belts, necklaces and patches can all make great conversation starters.

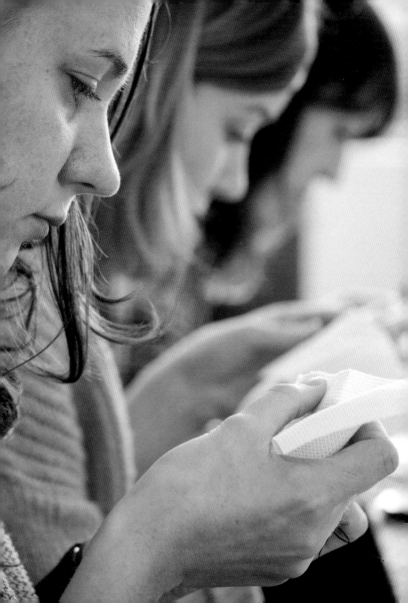

HOW TO BE A HAPPY CRAFTIVIST

Taking pleasure in what we do can sometimes feel at odds with the gravity of the issues we are confronting. Joy doesn't betray your activism, it sustains it in the face of defeatism. A positive message is a powerful one.

Make time to craft alone, not always in a group. It gives you a chance to focus on the issue you're crafting about without distraction.

✖✖✖

It's as important to keep yourself motivated as it is to motivate others. Make a craftivist piece to have at home or in the office to remind yourself to always try to be part of the solution and not the problem.

✖✖✖

Think about your own role in society before telling other people what they should do. What are your responsibilities as a consumer, voter, constituent, family member, colleague, etc? How can you fulfill those responsibilities to the best of your ability?

✖✖✖

Bear in mind that craftivism is about transformation over transaction. The Craftivist Collective is not about charity or getting something in return, it's about affecting change by provoking thought and discussion.

✖✖✖

As well as empathising with people suffering, make time to try and empathise with people in power: try and think about the challenges they face so that you can interact with them in a personal and respectful way.

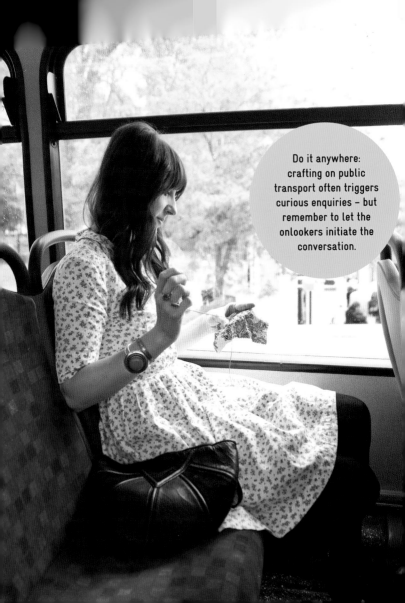

Do it anywhere: crafting on public transport often triggers curious enquiries – but remember to let the onlookers initiate the conversation.

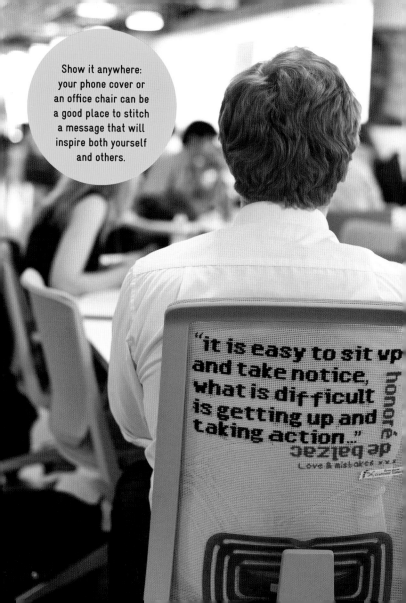

Show it anywhere: your phone cover or an office chair can be a good place to stitch a message that will inspire both yourself and others.

"it is easy to sit up and take notice, what is difficult is getting up and taking action.."

honoré de balzac

Love & mistakes xxx

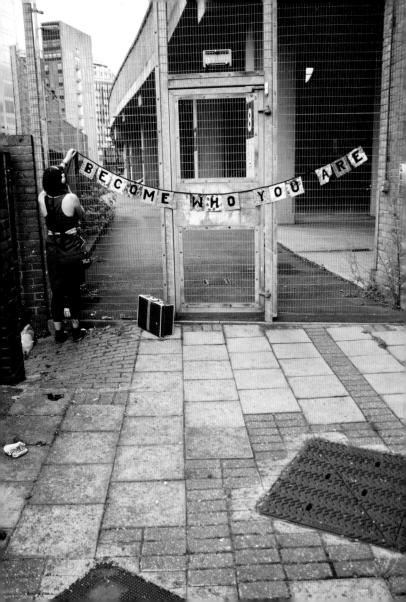

BUNTING

- - - - - - - - - - - - - - - - - -

NOTHING IS MORE NOSTALGIC AND NON-THREATENING THAN BUNTING; SO IT'S
PERFECT FOR A HOPEFUL SHORT STATEMENT. HANG IT IN A LOCATION WHERE
THE COLOURS WILL STAND OUT AND ITS BEAUTY REMINDS PASSERS-BY THAT THE
WORLD CAN BE A WONDERFUL PLACE IF WE ALL KEEP WORKING TO IMPROVE AND
PROTECT IT. MY FAVOURITE STATEMENT IS "BECOME WHO YOU ARE", BECAUSE IT
ASKS PEOPLE TO BECOME THE BEST HUMAN BEINGS THEY CAN BE, USING THEIR
SKILLS AND PASSIONS TO IMPROVE THE WORLD. YOU CAN SEW A CRAFTIVIST
COLLECTIVE LABEL ONTO THE LAST FLAG SO THAT PEOPLE CAN FIND AN
EXPLANATION OF YOUR PIECE ON OUR BLOG.

Materials

- Pretty patterned cotton fabric
- Plain cotton or felt for the letters
- Sewing machine, or a needle and thread
- Bondaweb (optional)
- Cotton bias binding tape
- Craftivist Collective label

What to do

- Cut the fabric into the shape you want for your bunting flags. You can leave the fabric frayed if you want it to look unloved and delicate, or hem the edges for a clean finish.
- Cut out cotton or felt letters and pin them on your flags. You can also iron bondaweb to the letters and fabric if you like. Hand-stitch or machine stitch into place. Remember, the more handmade the letters look, the more endearing your craftivism piece is, so don't feel you have to make it too perfect.
- Sew your flags in a line using the bias binding tape, leaving approx 50cm extra at each end so that you can tie it around fences or railings (but never obstructing people from walking somewhere).
- Find a suitable spot for your bunting. Tie it in place, and cut off the excess tape.
- Take a photo, blog about it and share it on all your social media outlets and with all your contacts.

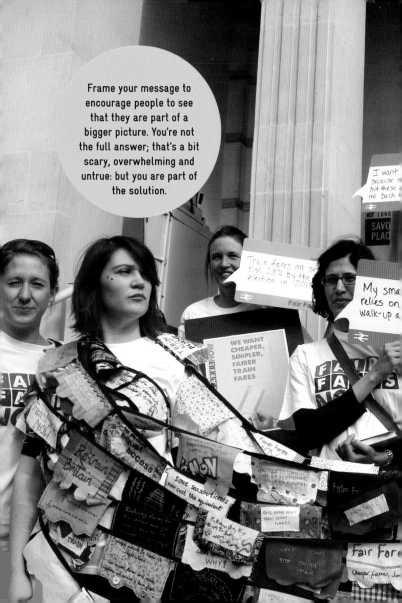

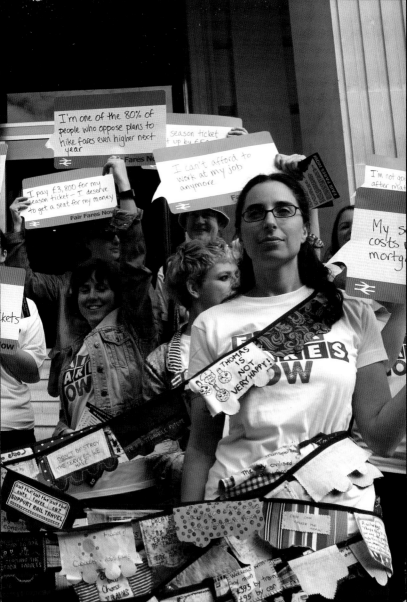

SPREADING THE WORD

Crafting in small groups of five or six people is ideal.
People will be curious and not scared to ask what's
going on.

✖✖✖

Find a popular area to craft in, but be respectful of the
venue/area. If it feels like you've hijacked the space,
you'll put people off.

✖✖✖

Place your piece of street art away from eye level so
people feel special that they have found it – they are
more likely to share your message with others if it's not
demanding their attention.

✖✖✖

Spread the word online. Twitter, Facebook, Instagram,
Pinterest and Tumblr are all powerful tools for conveying
your message. Post a picture and write about the piece
you have made; why you made it and where you put it.
Include links to relevant campaigns, and engage with any
comments or discussions that are prompted.

✖✖✖

Keep some mystery alive! While it's important to clearly
address the issues, if you can keep your message a little
bit cryptic, people are more likely to engage with a half-
hidden gem, and retweet/share.

✖✖✖

Keep your message relevant to whomever your likely
audience is. Your tone and approach might be different to
fashionistas, craft-lovers, bankers and politicians.

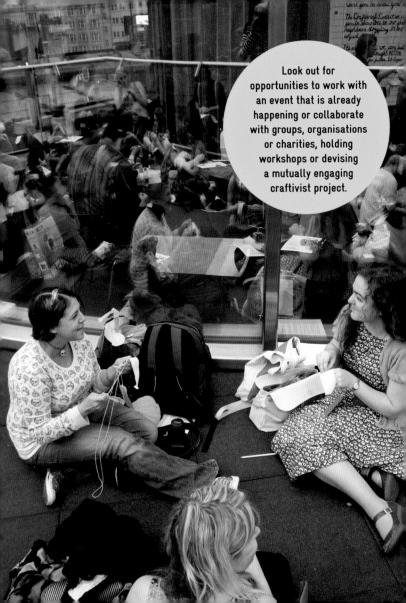

Look out for opportunities to work with an event that is already happening or collaborate with groups, organisations or charities, holding workshops or devising a mutually engaging craftivist project.

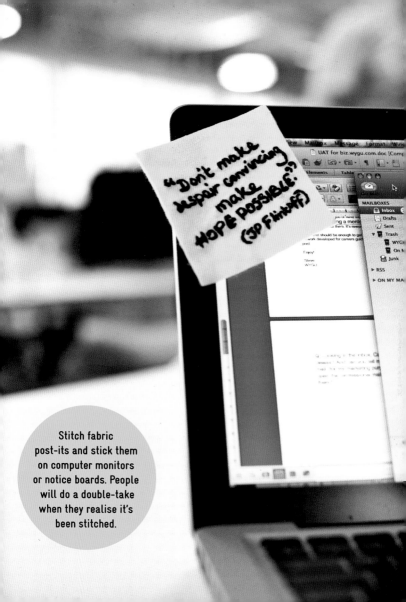

Stitch fabric post-its and stick them on computer monitors or notice boards. People will do a double-take when they realise it's been stitched.

@KatherineEluned: @emmagoingabroad check out this new movement Em... activism for creative introverts! Thought of you at todays @Craftivists workshop

@tomofholland: @Craftivists shows, inspires and facilitates craftsters to unite their individual creative powers to raise awareness of social issues.

@CarolineLucas: @skullsandponies Good to meet you today - love #imapiece project & wish #raceagainsthunger all success

@benhammersley: Really good talk from @Craftivists after me at tonight's @SalonLondon - has me doing embroidery on the tube home. Wonderful new meditation.

@storyofmum: I love the project - it's really inspiring&creative & has really got me excited about activism again in a way I haven't been since my teens!

@PrickYourfinga: At tonight's #craftivist stitch-in we talked about what it must be like to be a politician, and how to activate change in our busy lives.

@UnaDevine: I love the idea of crafts being subversive and a tool for change. Check out @Craftivists to see how!

@MadeByMolu: I LOVE how we can turn a political campaign into a peaceful&poetic one. With the right people power, I have no doubt we could move mountains!

@NorthWestNosh: #craftivism encourages craftsters to engage with activism in our own quiet way. Sometimes the quieter the revolution, the louder it is heard.

@RinSimpson: My small act of craftivism will, hopefully, go some small way towards changing the world. But more importantly, it has changed me.

@SimonWrightMP: Thank you @gtgwi craftivists for the fantastic stitched #imapiece messages against hunger.

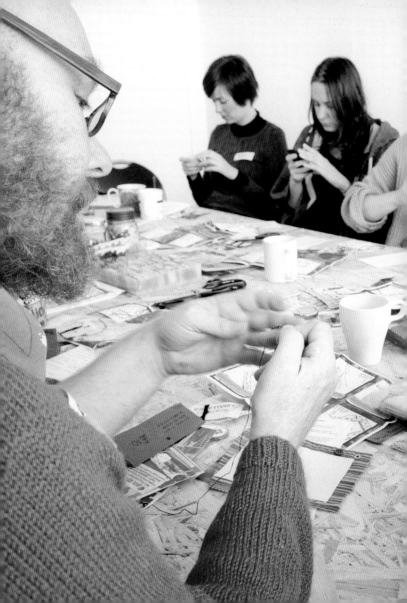

POWER IN NUMBERS

It's great to craft on your own, but there is a pleasure to crafting in groups too. Stitching with other people can create a safe space where crafters feel connected to one another, in solidarity on an issue. People in the group can help each other out with the craft and also with the complexities of the issue at hand, discussing it honestly and openly. These are a few ideas for projects that work well as a group:

Sit under a tree and embroider leaf-shaped pieces of fabric with messages about protecting our planet. Leave them hanging from the tree for people to notice, or invite a relevant person, company or politician to sit under the tree and engage with the issue.

✖✖✖

Write messages on origami birds or stitch messages on fabric birds and hang them under a bridge or inside a pedestrian tunnel so they skim the tops of people's heads, inviting passers-by to read the messages.

✖✖✖

Embroider messages on patches and sew the patches together to create a giant quilt, or alternatively sew them together with bias tape on a long piece of bunting.

✖✖✖

Ask each person to stitch a word for a giant petition, and then get them to stitch their signatures on it. Hang it for all to see.

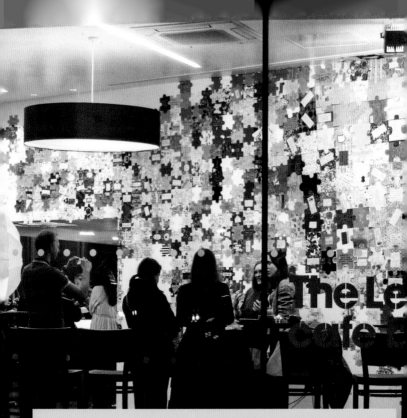

I'M A PIECE

THE CRAFTIVIST 'I'M A PIECE' JIGSAW PROJECT WAS IN SUPPORT OF SAVE THE
CHILDREN'S 'RACE AGAINST HUNGER' CAMPAIGN. WE ASKED PEOPLE TO CREATE
THREE HAND-STITCHED JIGSAW-SHAPED PATCHES EACH; ONE TO BE DISPLAYED
IN OUR HUGE PUBLIC INSTALLATION OF PATCHES FROM PEOPLE FROM ALL OVER
THE WORLD; THE SECOND FOR THE MAKER TO KEEP AT HOME FOR PERSONAL
INSPIRATION AND THE THIRD TO BE SENT TO THEIR LOCAL MP, ENCOURAGING THEM
TO BE PART OF THE SOLUTION TO END WORLD HUNGER.

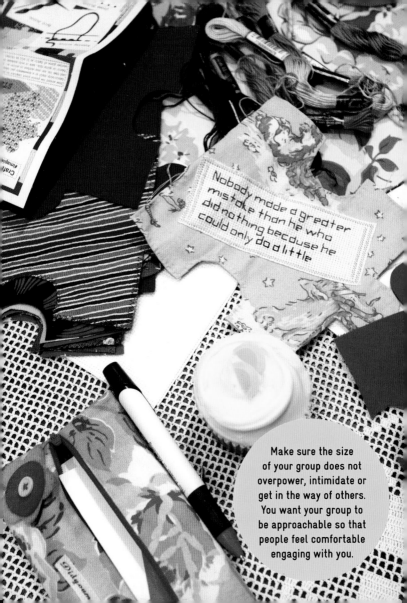

Nobody made a greater mistake than he who did nothing because he could only do a little

Make sure the size of your group does not overpower, intimidate or get in the way of others. You want your group to be approachable so that people feel comfortable engaging with you.

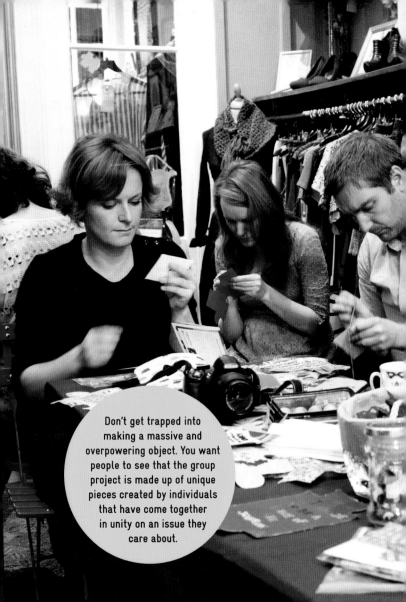

Don't get trapped into making a massive and overpowering object. You want people to see that the group project is made up of unique pieces created by individuals that have come together in unity on an issue they care about.

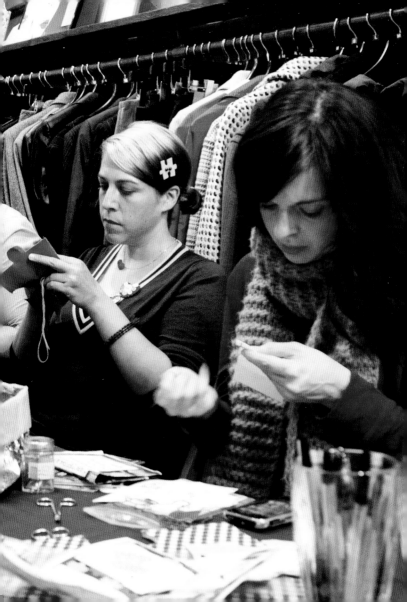

CRAFTER - THOUGHT

I hope this book gives an understanding of how the Craftivist Collective uses craft as a form of activism, to make a positive difference in our world and also within ourselves.

It's easy to slip into defeatism – to think that one person cannot make a difference in the face of the enormity of the world's needs. But don't forget that one woman, Rosa Parks, was a catalyst for the civil rights movement. To remind myself never to give up striving for a better world, I have embroidered the words of anthropologist Margaret Mead into my craftivism suitcase: "Never doubt that a small group of thoughtful, committed citizens can change the world. Indeed, it is the only thing that ever has."

Activism should be threaded through all of our lives, in everything we do. Not just when we craft, but when we vote, shop, travel, in all our interactions with people, and in all the decisions we make. Craftivism isn't the answer to everything: there is no quick fix. But we can all be part of the solution and craftivism allows us to express ourselves, and to create safe spaces for honest, open conversations. With that positivity in our hearts we can reach out to others, not aiming to force change, but with the hope that we can be a critical friend to each other and that through collective decision-making and common action we can make the world a better place.

Justice isn't something we wait for, it's something we MAKE. So go on, keep trying to be the change you wish to see in the world and in yourself. Keep craftivism in your activism toolkit, and use it when appropriate. Please share this book with friends. Use it as a conversation starter about our world. And keep in touch: we would love to see your craftivism projects on Twitter, Instagram or on our website, www.craftivist-collective.com.

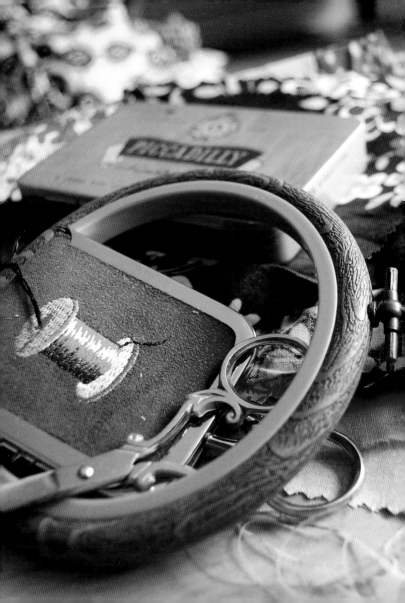

This book was made possible by partial funding from the following craftivists and supporters from around the world:

Liz Aab
Max Alexander
Cheryl Anderson
Joanne Armstrong
Vanessa Bancroft
Sarah Beeston
Momtaz Begum-Hossain
Michal Berg
Juliet Bernard
Michelle Berry
Michaela Bertrand
Andrea Blevins
Maya Rose Boodhun
Mark Bracegirdle
Jayde Bradley
Olivera Bratich
Joanna Bricher
Karina Brisby
Ele Buckley
Chloe Burrow
Susan Burwash
Loraine Bussard
Maria Elena Buszek
Fabienne Katy Camm
Cath Carver
Cat's Pajamas Creations
Jamie Chalmers
Christopher Chang

Teresa Collenette
Alice Conde
Cinnamon Cooper
Natalie Cooper
Clare Corbett
Emma Corbett
Patricia Corbett
Thomas Corbett
Sue Cullen
Jennifer de Chickera
Tim Denshire-Key
Nancy Dick
Claire Drake
Erica Durante
Kim Edwards
Carina Envoldsen-Harris
Amanda Ericsson
Viv Ervine
Chris Everett
Rayna Fahey
Naomi J Falk
Katherine 'Freddie' Fitton
JP Flintoff
Mary Foulerton
Kizzy and Myles Gardiner
Liz Gibson
Helen Green

Betsy Greer
Anne Gregory
Annie Harries
Lynn Harrigan
Jenny Hart
Vicky Haynes
Tina Helfrich
Oyvind Henriksen
Cathy Hoste
Margo Howie
Sara Hughes
Lucy Hurn
Becky Hurst
Rosie James
Maddie Janes
Alison Jeffers
Casey Jenkins
Mary Ann Jennings
Christine Johnson
Garth Johnson
Jemma Jones-Hayes
Safiya Juma
Jerry W Kane
Sarah Kerry
Hannah Korkmaz
Eileen Laurie
Margery Lee
Sian Lile-Pastore

Sue Lines
Emma Lloyd
Karen Lobo-Morell
Sayraphim Lothian
Marjory Jane Lothian
Ellen Loudon
Carrie Maclennan
Ellie MacPherson
Viv Manning
Rachael Matthews
Joanne McAlroy
Lindsey McGrath
Isabelle McNeill
Michael Middleton-
 Downer
Suzanne Morlock
Alex Nightingale
Lotte Nuszer
Kath O'Donnell
Marta Owczarek
Chris Packe
Janet Patterson
Emma Pepler
Samantha Persons
Natasha Peter
Charlie Philips
Alannah Pirrit
Melanie Porodo

Jean Power
Hilary Pullen
Rebecca Ramsden
Lex Ranolph
Linnie Rawlinson
Josie Ray
Carrie Reichardt
Sara-Jane Rice
Malu Z Roldan
Ruth Rosselson
Jennifer Roth
Braj Scioscia
Lucy Scott
Lynsey Searle
Nikki Shaill
Peter Ernest Shaill
Shoreditch Sisters
Kate Shurety
Cate Simmons
Rin Simpson
Becky Smith
Kim Smith
Jeff Steer
Victoria Stephens
Rachel Stevens
Mary Sweeney
Rachel Tavernor
Casper ter Kuile

Sonja Todd
Sophie Tomlinson
Nicola Truong
Magdalen Tyler-Whittle
Mark Vyner
Samantha Wait
Tilly Walnes
Peter Yeo

Thank you all!

Acknowledgements

A huge thanks to the craftivists across the world for being part of the Collective, sharing your projects and thoughts and encouraging each other. Without you this book wouldn't have happened and I'm honoured to be part of our gang! Thanks to our lovely supporters, affectionately known as craptivists, ie. those who might not craft with us but whose support is invaluable. Thanks to all the photographers and craftivists whose work featured in this book. Thanks also to my friends and to my amazing and inspiring parents, brother and sis for their continual support, encouragement and time: every day I feel blessed and proud to be related to you. Finally, thanks to the super-talented and patient editor Ziggy, who has helped me squeeze my thoughts into this little book.

Published by Cicada Books Limited

Text by Sarah Corbett
Photography by Robin Prime,
Will Steer and Garry Maclennan
Design by April

British Library Cataloguing-in-
Publication Data.

A CIP record for this book is
available from the British Library.
ISBN: 978-1-908714-07-7

© 2013 Cicada Books Limited

Every effort has been made to
trace the copyright holders, but
if any have been inadvertently
overlooked the publishers will be
pleased to make the necessary
arrangements at the first
opportunity.

All opinions expressed within
this publication are those of the
authors and not necessarily of
the publisher.

Cicada Books Limited
48 Burghley Road
London, NW5 1UE

T: +44 207 209 2259
E: ziggy@cicadabooks.co.uk
W: www.cicadabooks.co.uk